www.bunkerhillpublishing.com

First published in 2005 by Bunker Hill Publishing Inc.
26 Adams Street, Charlestown, MA 02129 USA

10 9 8 7 6 5 4 3 2 1

Library of Congress Cataloging in Publication Data available from the publisher's office

ISBN 1 59373 044 6

Designed by Louise Millar
Copyedited by George T. Kosar, Ph.D., The Sarov Press

Printed in China

Freedom Trail Foundation
99 Chauncy Street, Boston, MA 02111-1703
(617) 357-8300
www.thefreedomtrail.org

The Freedom Trail

AN ARTIST'S VIEW

Musket & drum from the collection in the Old State House Museum

Leonard Weber

written in collaboration by
Linda C. McConchie · Caitlin D. Shanahan · Ellis S. Jones

BUNKER HILL PUBLISHING
BOSTON

in association with **The Freedom Trail Foundation**

The Boston Common

America's oldest public park, the Boston Common began as a common grazing ground for sheep and cattle. Eccentric Anglican William Blackstone settled here in 1622 with only his books for company. In 1630, Puritans from Charlestown joined him to share the area's potable springs, but by 1635 Blackstone bristled at the increased population and moved to roomy Rhode Island to satisfy his reclusive nature. He returned to Boston on a white bull some years later to propose to his beloved.

The Common has provided space for a "trayning field" for British militia, as well as a place to hang pirates and witches and publicly pillory criminals in "stocks." It has also served a higher purpose as a place for public oratory and discourse. Reverend Martin Luther King spoke here, Pope John Paul II said Mass here, and Gloria Steinem advanced the feminist revolution on these grounds. These days, visitors to the Common can enjoy a concert, a performance of Shakespeare, or the simple, calm respite from the bustle of city life.

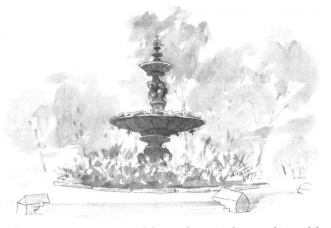

The Brewer Fountain, copied from a fountain that was designed for the Paris World's Fair of 1855. Cast in Paris and shipped to America as a gift for the people of Boston by Gardner Brewer, Esq.

"We need the tonic of nature."
HENRY DAVID THOREAU

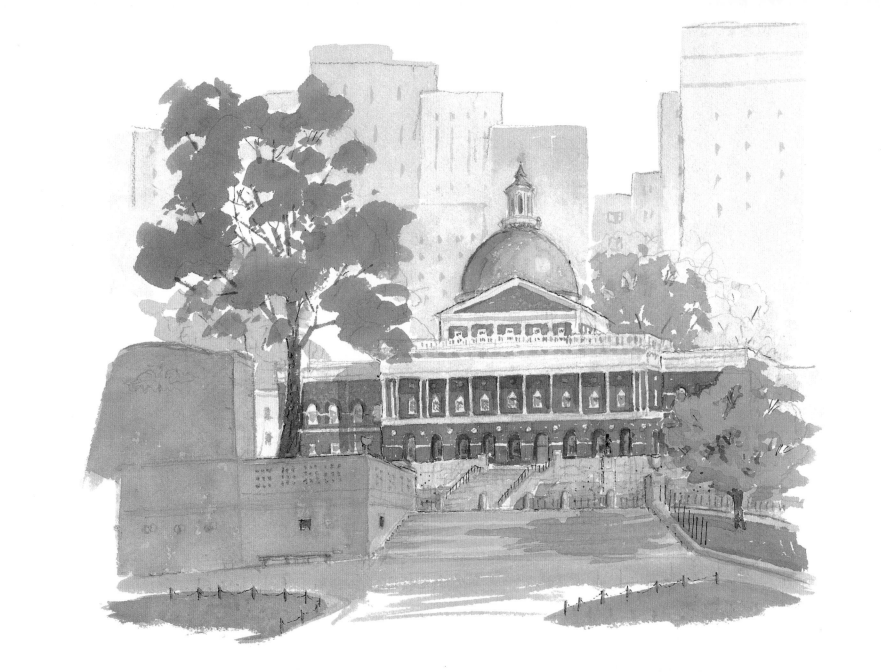

The State House

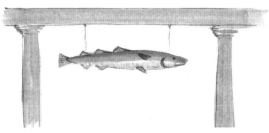

The Sacred Cod that hangs in the Massachusetts Senate Chamber, to the right when the Republicans are in power, to the left when power belongs to the Democrats.

Designed by renowned Boston architect Charles Bulfinch, the "new" State House remains one of Boston's most imposing and important buildings. Its golden dome—all 23 carats of it—was once made of wood, and later overlaid with copper by Paul Revere to prevent leaks. Now it glints like the beacon that once topped Boston's highest peak. It stands on what we now call Beacon Hill, and it is under the golden dome that state senators, state representatives, and the governor conduct the daily business of the Commonwealth of Massachusetts.

A visit to the House Chamber inside the State House will be rewarded with a first-hand view of the infamous Sacred Cod. The life-size wood fish that hangs in the Chamber was created in 1784 as a reminder of the importance of the Cod fishing industry to the state's economy. Why infamous? Because in 1933 it was "codnapped" by pranksters from the Harvard Lampoon. Chamber business was suspended for four days until it was recovered. The fish has remained on its perch above the Chamber ever since.

A carved wooden pine adorns the top of the Golden Dome, as a symbol of the state's reliance on logging in the eighteenth century. Happily, this icon has never been abducted.

"May the principles of our excellent Constitution, founded in Nature and in the Rights of Man, be ably defended here: And may the same principles be deeply engraven in the hearts of all citizens."

GOVERNOR SAMUEL ADAMS, ASSISTED BY PAUL REVERE, AS HE LAID THE CORNERSTONE, JULY 4, 1795.

Park Street Church

The 217-foot steeple of this church was once the first landmark travelers saw when approaching Boston. Its lofty architecture reflects an even loftier mission of human rights and social justice. Prison reform began in this church, women's suffrage was strongly supported here, and some of the first and most impassioned protests against slavery were delivered inside these hallowed walls.

The site of Park Street Church is known as "Brimstone Corner" perhaps because the congregation once stored "brimstone," or sulfur (a component of gun powder), in its basement during the War of 1812. Or maybe it's because old-school ministers delivered many a "hell-fire and brimstone" sermon here. This tradition of oratory continues, as passers-by often become audiences to the testimony of many different denominations; Brimstone Corner has become the pulpit of many impromptu preachers and prophets.

Park Street Church can also be remembered for a more peaceful event. "My Country 'Tis of Thee" was sung for the very first time from the steps of this church on July 4, 1831.

"My country is the world, my countrymen, mankind."
WILLIAM LLOYD GARRISON,
ABOLITIONIST

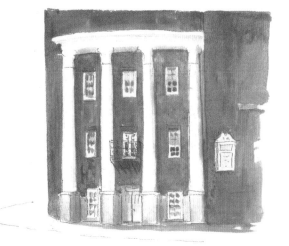

The balcony of the Park Street Church.

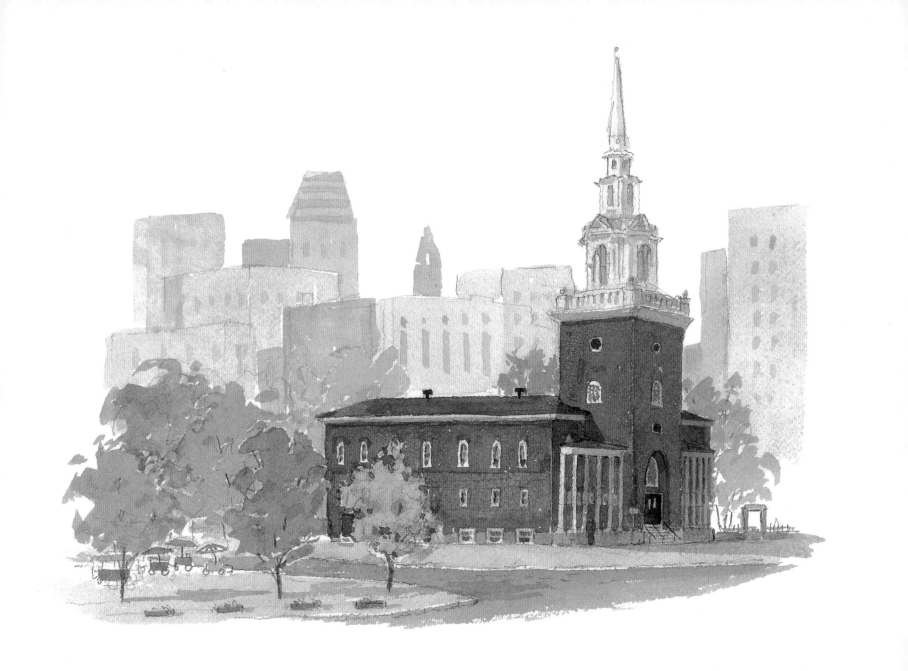

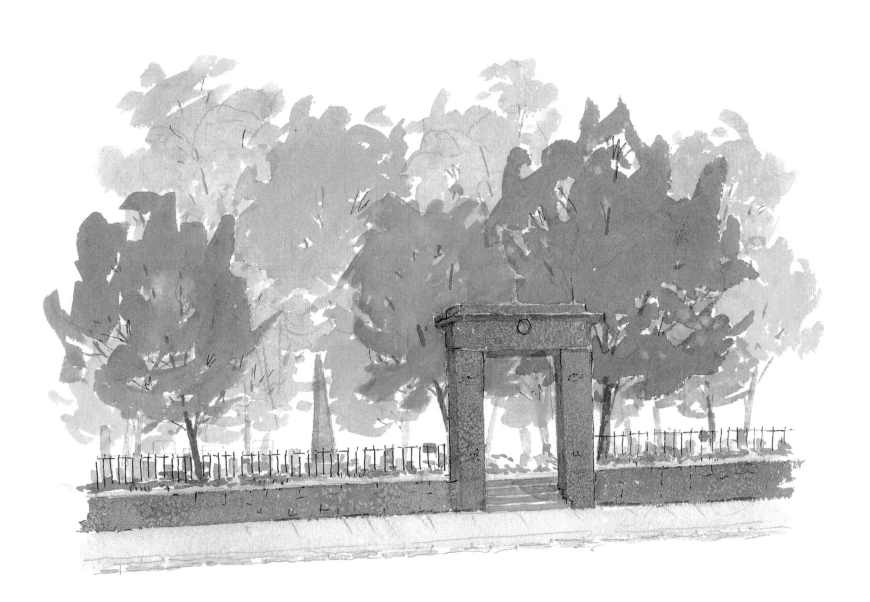

Granary Burying Ground

Called by some "America's Westminster Abbey," the Granary Burying Ground's tranquility and beautifully carved stone markers offer solace and a place for contemplation.

Some of America's most notable citizens rest here. An elaborately embellished obelisk marks the site of John Hancock's tomb. Nearby rests his servant Frank. Although Frank's marker is humble, the fact that his resting place is marked at all is a sign that his employer held him in very high esteem. Other Revolutionary heroes buried here include Paul Revere, Samuel Adams, James Otis, all five of the Boston Massacre victims, Benjamin Franklin's parents, and Peter Faneuil.

Although the Granary contains only 2,300 markers, it is estimated that more than 5,000 people are buried here. Perhaps the discrepancy is explained by some changes to the Granary following the invention of rotary lawn mowers, which prompted grounds keepers to arrange the stones in neat rows to facilitate maintenance.

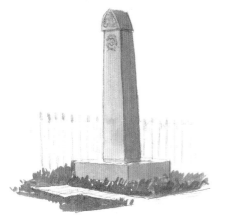

The final resting place of the first signer of the Declaration of Independence, John Hancock, 1737–1793.

"Stranger stop and cast an eye
As you are now, so once was I
As I am now, so you shall be
Prepare for death and follow me"

EPITAPH FROM THE GRAVESTONE
OF JOHN DECOSTER
IN GRANARY BURYING GROUND

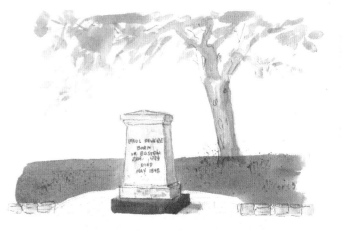

Tomb of midnight rider Paul Revere, 1734–1818.

King's Chapel and Burying Ground

Intoxicating music flows from the interior chamber and past the imposing pillars of this venerable church during daily noontime concerts. A celestial tribute, and one that seems fitting for a place of worship that was built on the command of a king. King's Chapel was the first church in America to acquire an organ, and this one, which was approved for use by the famous organist of London's Temple Church, John Stanley, is encased inside a replica of the original built by Richard Bridge of London.

King's Chapel was built on land seized by King James II in 1686 after the townspeople refused to sell him any. By 1749 the original wooden church had become too small for the congregation, so the present stone structure was built around it to avoid disturbing services. The church's exterior columns appear to be stone, but in fact are painted wood, a cost-saving *trompe l'oeil*. Paul Revere crafted King's Chapel's 2,347-pound bell in 1816, and he proclaimed it the "sweetest sounding" he had ever created.

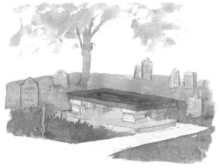

*Tomb of John Winthrop, 1588–1649,
the Colony's first governor, famous for referring
to Boston as a "city on a hill." ". . . for we must
consider that we shall be as a city on a hill.
The eyes of all people are upon us." – J. Winthrop.
"You are the light of the world. A city on a hill
cannot be hidden." – Matthew 5:14.*

*"In his conversations and writings shone keen insight,
wit, devotion to truth, love of home, friends and country
and a cheerful philosophy. A true son of New England,
his works declare their birthplace and their times . . ."*

EPITAPH TO OLIVER WENDELL HOLMES,
GREAT BOSTON WRITER AND A MEMBER
OF THE CONGREGATION, WRITTEN ON
A STONE TABLET IN KING'S CHAPEL.

*Tomb of William Dawes, Jr., another midnight
rider on April 18, 1775, who met with Revere
in Lexington and escaped when Revere was
captured by Redcoats on the way to Concord.*

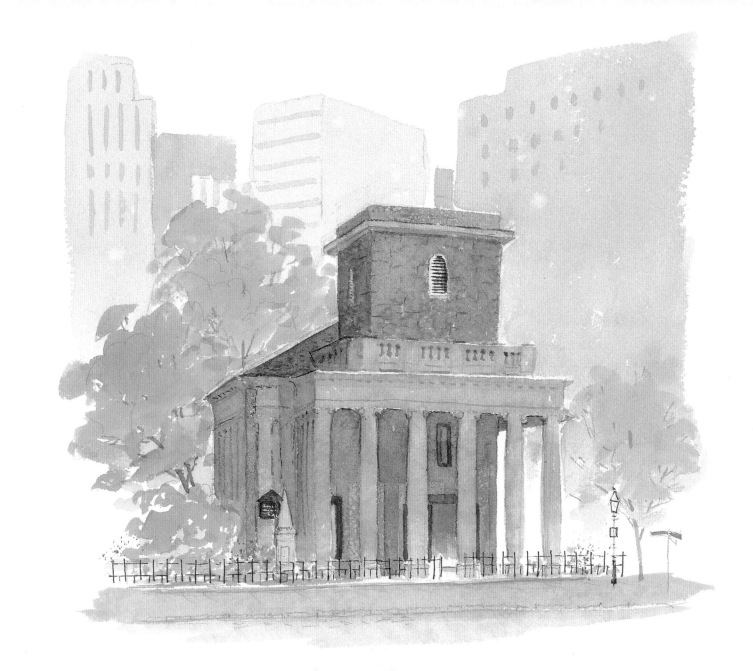

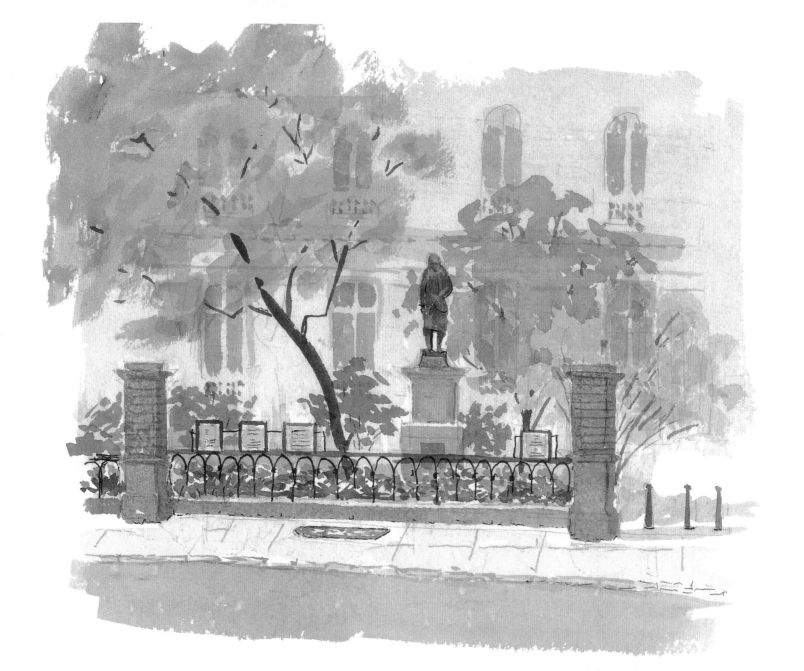

Site of First Public School, Boston Latin

America's first public school offered instruction here free of charge to boys, rich or poor, while girls attended private schools in peoples' homes. The boys-only tradition finally ended in 1972 when girls were permitted to attend Boston Latin. It is fabled that on April 19, 1775, when word of shots fired in Lexington circulated rapidly throughout Boston Town, Boston Latin's instructor John Lovell was inspired to rise and rhyme "Close your books. School's done, and war's begun!"

This striking mosaic marks the spot where the school once stood, and where one of its most famous students, Benjamin Franklin, attended classes not long before he dropped out of school forever.

"Genius without education is like silver in the mine."

THE-MOSTLY-SELF-EDUCATED STATESMAN,
BENJAMIN FRANKLIN

Plaque marking the former site of Boston Latin School, the first Public School in the colonies, founded in 1635. Famous alumni include John Hancock and Samuel Adams; famous dropouts include Ben Franklin.

Old Corner Bookstore Building

The windows of this lovely old building once gave natural light to editors who pored over the galleys of *Walden, The Scarlet Letter, Hiawatha,* and the *Atlantic Monthly.* Ticknor & Fields, the nation's leading publisher from 1833 to 1864, made its home here, publishing the works of Henry Wadsworth Longfellow, Harriet Beecher Stowe, Nathaniel Hawthorne, Ralph Waldo Emerson, John Greenleaf Whittier, Oliver Wendell Holmes, Charles Dickens, and Louisa May Alcott.

The original building on this site was owned by Mary Hutchinson. Feisty and outspoken, Mary Hutchinson openly expressed her views about religion and about women's rights. She was banished from Massachusetts in 1638 for her audacious beliefs.

"Such guests! What famous names its record boasts,
Whose owners wander in the mob of ghosts!
...would I could steal its echoes! You should find
such store of vanished pleasures brought to mind."

FROM OLIVER WENDELL HOLMES' AT THE SATURDAY CLUB,
ABOUT THE PLACE WHERE MANY FAMOUS TICKNOR & FIELDS AUTHORS
GATHERED TO EXCHANGE IDEAS AND ENJOY EACH OTHER'S COMPANY.

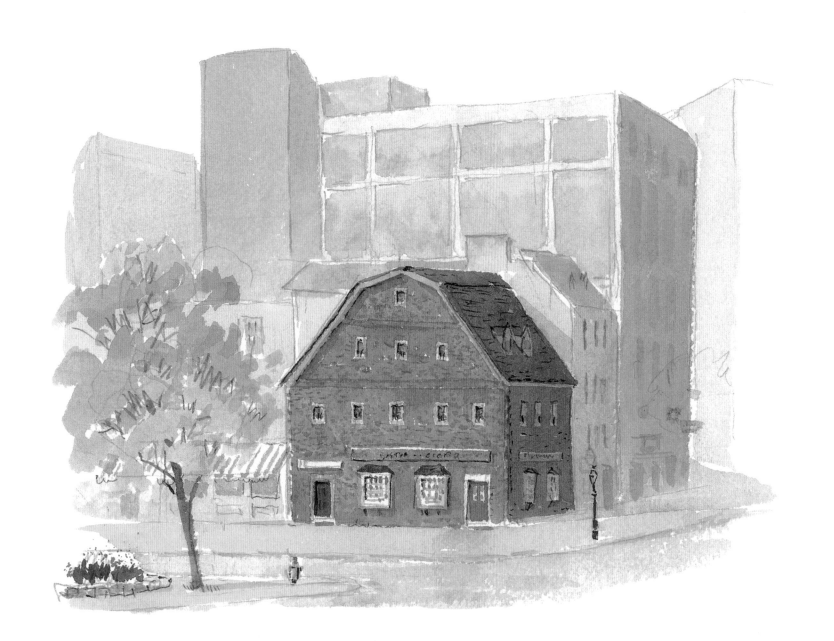

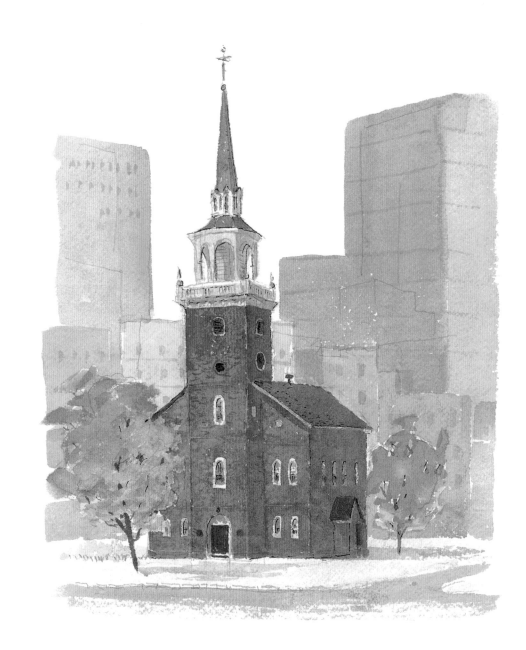

Old South Meeting House

Old South was the largest building during the time of the Revolution, and big things happened inside. This old church furnished Boston's boisterous patriots with a stage for their impassioned protests. They even started the Boston Tea Party here after Samuel Adams delivered his now famous coded message. "There is nothing more this meeting can do to save our country, the time for action has arrived!" he declared to the assembly. Colonists, led by the Sons of Liberty and disguised as Native Americans, left Old South and walked quietly and purposefully to the waterfront, where they dumped 342 chests of tea into the harbor.

British soldiers soon retaliated, turning this "sanctuary of freedom" into a place to drink liquor and exercise their horses.

Old South is now a museum but was almost lost forever when it was slated for demolition in 1876. Determined preservationists saved it within minutes of the wrecker ball's first strike.

"Here the men of Boston proved themselves independent, courageous freemen worthy to raise issues which were to concern the liberty and happiness of millions yet unborn."

ANONYMOUS POEM

Margaret Sanger protesting the lack of freedom of speech.

The Freedom Trail

The Boston Common

Bounded by Tremont, Park, Beacon, Charles, and Boylston Streets
Boston Common Visitor Center: 146 Tremont St.
(617) 426-3115
www.bostonusa.com
8:30am-5pm Mon-Fri, 9am-5pm Sat-Sun
Public Transportation: Park St. Station, Red Line and Green Line
Parking: Boston Common Garage (617) 954-2096
 Charles St. across from the Public Garden

The State House

24 Beacon Street; corner of Beacon and Park Streets
(617) 727-3676
Tours: www.state.ma.us/sec/trs
Hours: 9am-5pm Mon-Fri, 10am-4pm Sat
Public Transportation: Park St. Station, Red Line and Green Line

Park Street Church

1 Park Street; corner of Park and Tremont Streets
(617) 523-3383
www.parkstreet.org
Public Transportation: Park St. Station, Red Line and Green Line

Old Granary Burying Ground

Tremont Street; adjacent to Park St. Church
(617) 635-4505
www.cityofboston.gov/parks/hbgi
Hours: Spring, Summer & Fall Daily 9am-5pm
Winter 9am-3pm

King's Chapel & Burying Ground

58 Tremont Street; corner of Tremont and School Streets
(617) 227-2155
www.kings-chapel.org
Hours: Year-round Sat 9am-4pm
Mem. Day-Vet. Day Mon, Thurs, & Fri 9am-4pm
Public Transportation: Government Center Station, Green Line

Site of First Public School, Boston Latin & Ben Franklin Statue

School Street
Public Transportation: Government Center Station, Green Line

Old Corner Bookstore Building

1 School Street; corner of School and Washington Streets
www.historicboston.org
Public Transportation: Downtown Crossing Station, Orange Line and Red Line;
State Street Station, Orange Line and Blue Line

Old South Meeting House

310 Washington Street; corner of Milk and Washington Streets
(617) 482-6439
www.oldsouthmeetinghouse.org
Hours: Apr-Oct 9:30am-5pm; Nov-Mar 10am-4pm
(Closed Thanksgiving, Dec 24, 25, and Jan 1)
Public Transportation: Downtown Crossing Station, Orange Line and Red Line;
State Street Station, Orange Line and Blue Line

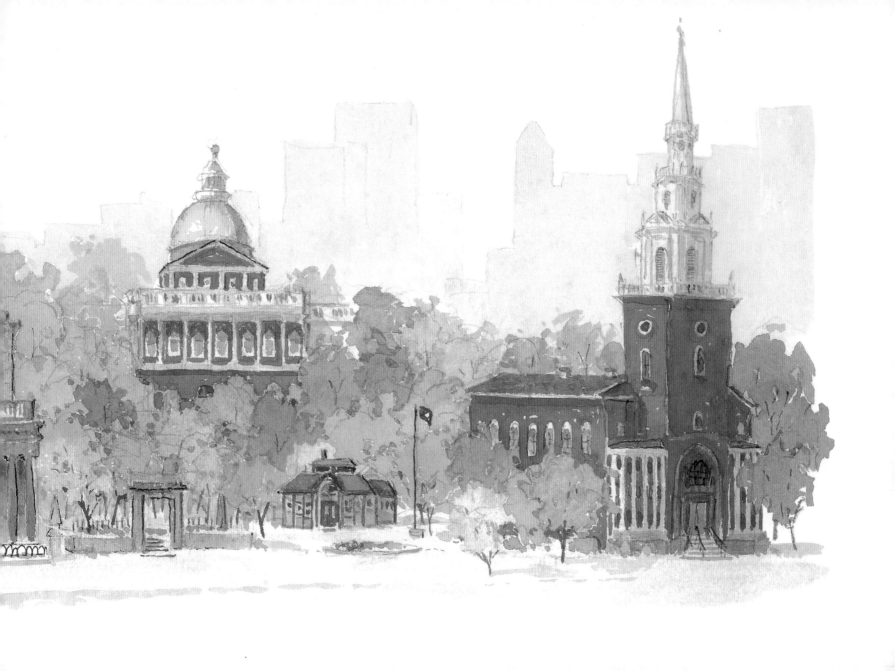

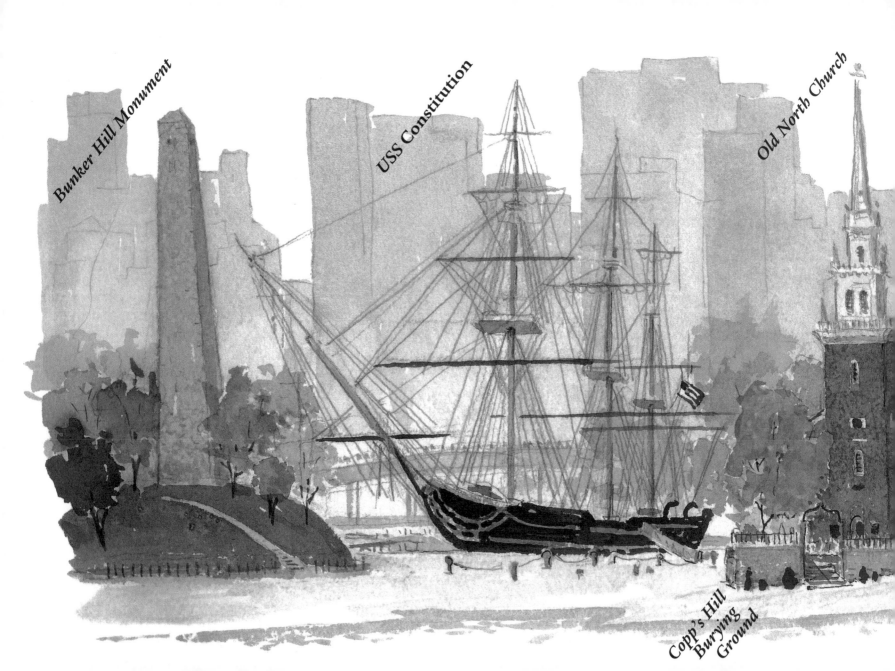

Bunker Hill Monument

USS Constitution

Old North Church

Copp's Hill Burying Ground

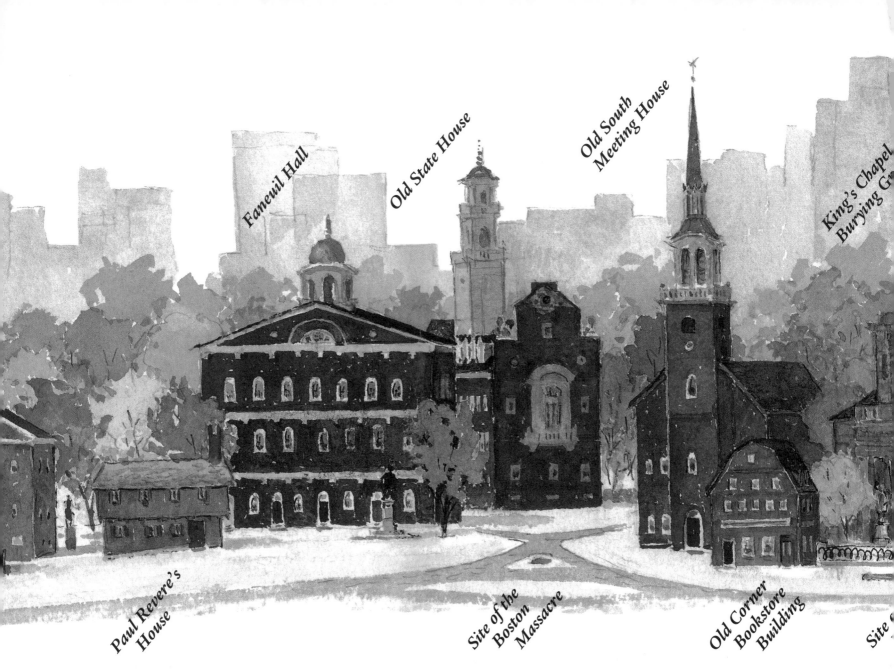

Paul Revere's House

Fanewil Hall

Old State House

Old South Meeting House

King's Chapel Burying Gr

Site of the Boston Massacre

Old Corner Bookstore Building

Site

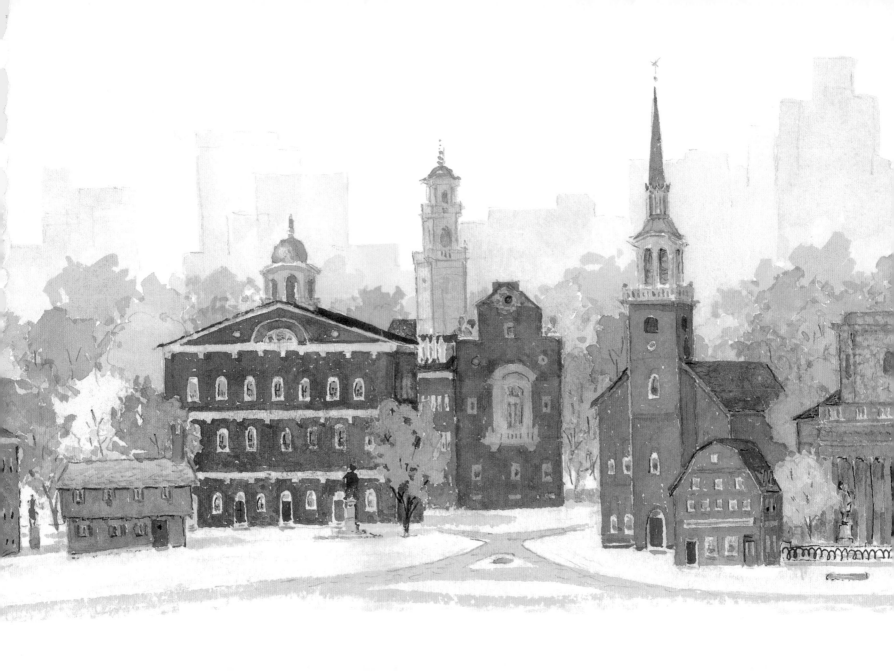

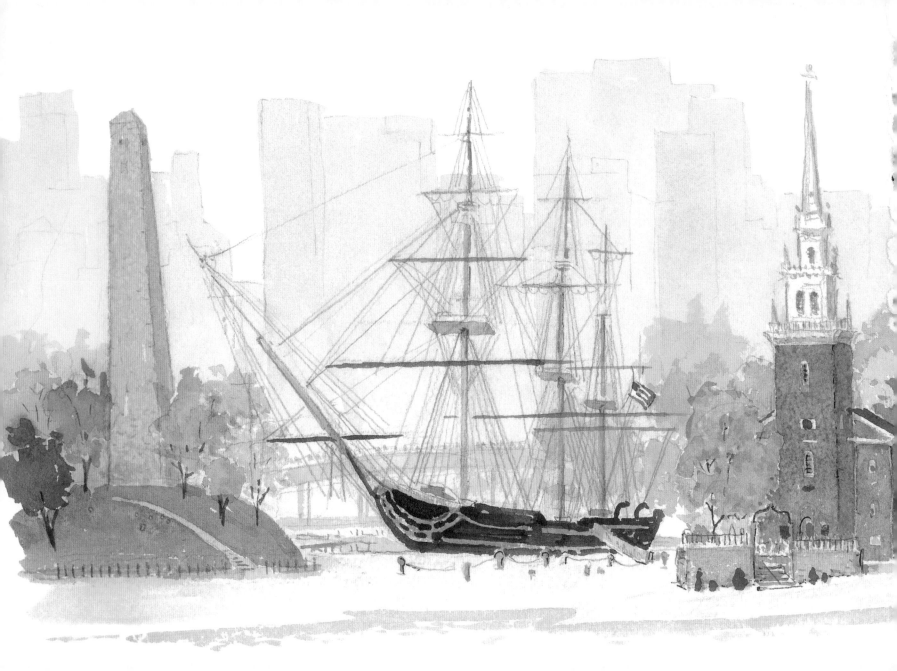

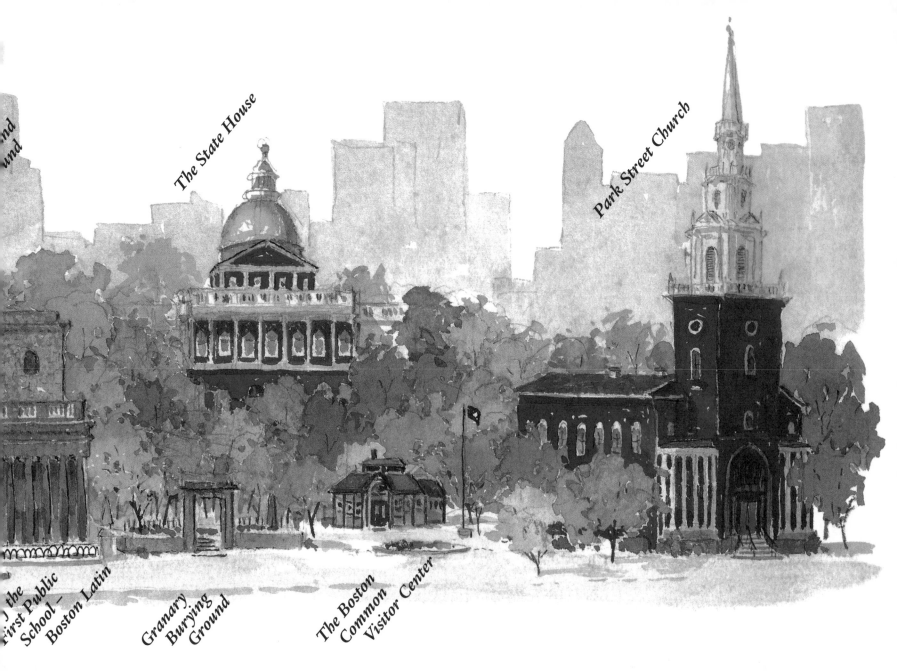

The State House

Park Street Church

the
First Public
School –
Boston Latin

Granary
Burying
Ground

The Boston
Common
Visitor Center

Old State House

206 Washington Street; corner of State
and Washington Streets
(617) 720-1713
www.bostonhistory.org
Hours: Museum, Daily 9am-5pm
(Closed Thanksgiving , Dec 25, and Jan 1)
Library, Tues-Thurs 9:30am-4:30pm
(Closed holidays)
Public Transportation: Government Center
Station, Green Line;
State Street Station, Orange Line and Blue Line

Site of the Boston Massacre

A circle of cobblestones in a traffic island; look
east from Old State House
Public Transportation: State Street Station,
Orange Line

Faneuil Hall

Dock Square adjacent to Quincy Market
(617) 635-3105
www.nps.gov/bost/Faneuil_Hall.htm
Hours: 9am-5pm Daily, except when used for
public functions (Closed Thanksgiving, Dec 25,
and Jan 1)
Public Transportation: Government Center
Station, Green Line;
Aquarium Station, Blue Line

Paul Revere House

19 North Square
(617) 523-2338
www.paulreverehouse.org
Hours: Daily Apr 15-Oct 31, 9:30am-5:15pm; Nov
1-Apr 14, 9:30am-4:15pm (Closed Thanksgiving,
Dec 25, and Jan 1, Mondays Jan–Mar)
Public Transportation: Haymarket Station,
Orange Line and Green Line;
Aquarium Station, Blue Line

Old North Church

193 Salem Street
(617) 523-6676
www.oldnorth.com
Hours: Daily 9am-5pm
Public Transportation: Haymarket Station,
Orange Line and Green Line

Copp's Hill Burying Ground

Entrances at Charter and Hull Streets
(617) 635-4505
www.cityofboston.gov/parks/hbgi
Public Transportation: Haymarket Station,
Orange Line

USS *Constitution* – "Old Ironsides"

Charlestown Navy Yard
(617) 242-5670
www.ussconstitution.navy.mil
Hours: Tues-Sun, 10am-3:50pm

USS Constitution Museum

(617) 426-1812
www.ussconstitutionmuseum.org
Hours: May 1-Oct 15, 9am-6pm; Nov 1- Apr 30,
10am-5pm (Closed Thanksgiving, Dec 25, and Jan 1)
Public Transportation: #93 Bus from Haymarket
Station, Orange Line, Commuter Ferry at Long Wharf
Parking: Nautica Garage, 88 Constitution Rd.
(617) 337-0068

Bunker Hill Monument

Monument Square, Charlestown
(617) 242-5641
www.nps.gov/bost/Bunker_Hill.htm
Hours: Daily 9am-4:30pm
Public Transportation: #93 Bus from Haymarket
Station, Orange Line, Commuter Ferry at Long
Wharf

Old State House

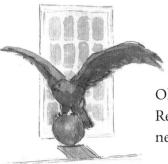

Gilded Eagle on one end of the Old State House, installed during the 1882 restoration.

Old State was the seat of British Government during the Revolution. After the Revolution, it became the Commonwealth's first state house and remained so until the new one was completed in 1798.

This splendid structure served as the backdrop for the tragic deaths of Crispus Attucks and four others who died in the Boston Massacre. Six years later, it was from this balcony that the Declaration of Independence was first read to the people of Boston. Abigail Adams was there that day. She watched as the exhilarated crowd tore down the golden lion and the silver unicorn, symbols of British rule. "Great attention was given to Colonel Graft's every word," she wrote to her husband John. "As soon as he ended, the cry from the balcony was God Save Our American States and then three cheers rended the air...Thus ends royal authority in this state and all the people shall say, Amen."

The lion and the unicorn have been restored, and Old South is now a museum of Boston history.

"...we hold these truths to be self-evident, that all men are created equal, that they are endowed by their Creator with certain unalienable Rights, that among these are Life, Liberty and the pursuit of Happiness."

THE DECLARATION OF INDEPENDENCE

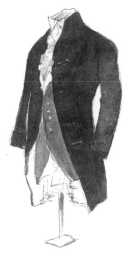

Coat, vest, and shirt worn by John Hancock. The coat may very well be the one Hancock wore to his inauguration as the first elected governor of Massachusetts.

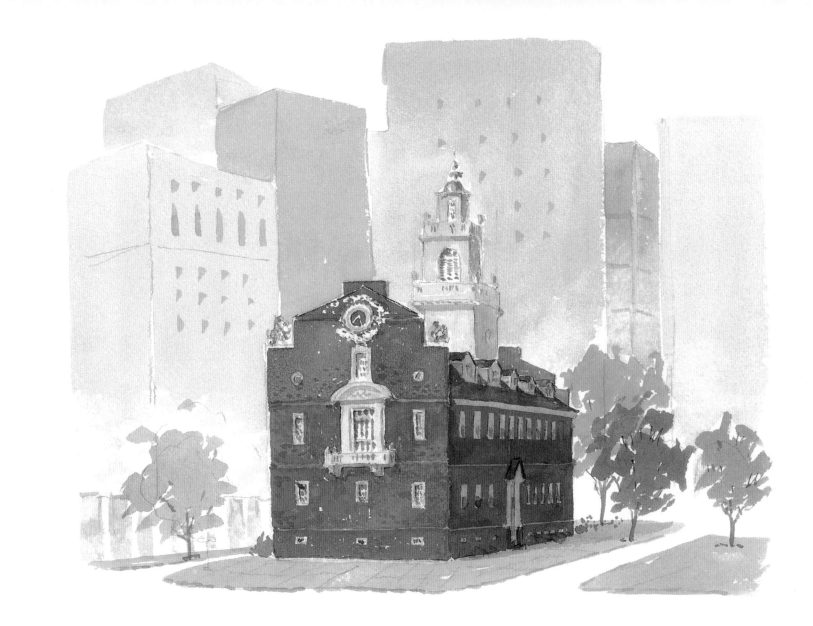

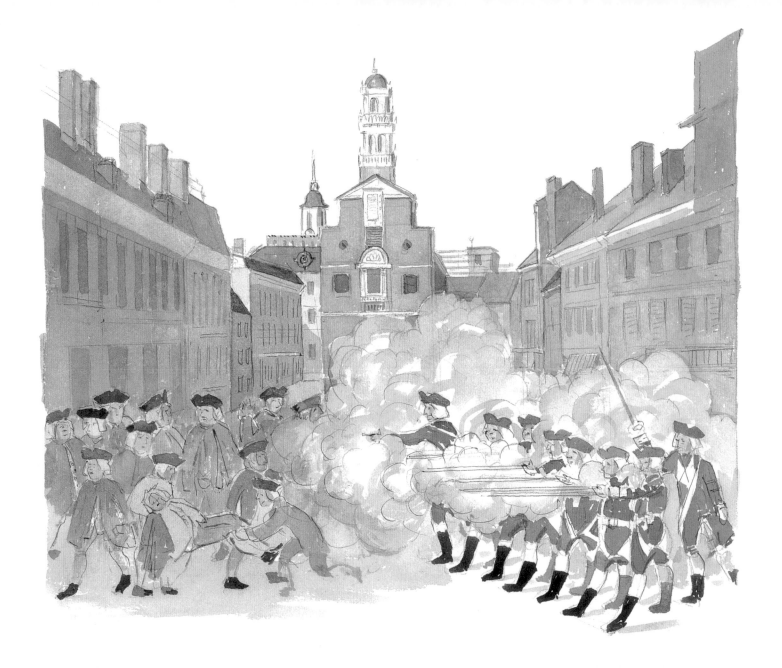

Site of the Boston Massacre

On this site, a skirmish between an angry group of colonists and a few terrified British soldiers erupted into the first deadly encounter between Boston colonists and British "red coats."

The trouble began when a crowd of angry colonists left a local tavern and approached a British sentry standing guard outside on a chilly March 5, 1770. According to John Adams, they were "a motley rabble of saucy boys" who had assembled around an argument between a young boy and a soldier. Eyewitness accounts of the event are confusing. The boy was struck with the barrel of a musket by a sentry, and the crowd became a mob. They threw sticks, ice snowballs, and rocks at the young British guards, and finally a wooden club knocked one of the sentries to the ground.

It might have been their jeering taunt "fire, fire, why don't you fire? You dare not fire?" that caused the confusion, or the panic of the young British soldiers who were outnumbered and under attack, but fire they did and within seconds eleven colonists were dead or wounded.

Samuel Adams and Paul Revere seized upon the tragedy to spark a flame of anger among the colonists by representing the skirmish as a massacre. The British soldiers were tried for murder. John Adams, a Boston lawyer and ardent patriot, defended them in spite of his contemporaries' view that the event was a "horrible and bloody massacre." He was as loyal to the ideal of justice as he was to the patriot cause.

"...facts are stubborn things, and whatever may be our wishes, our inclinations or the dictates of our passions, they cannot alter the state of facts and evidence."

JOHN ADAMS

Faneuil Hall

Often referred to as "the home of free speech" and "the cradle of liberty," Faneuil Hall hosted America's first Town Meeting. Built by wealthy merchant Peter Faneuil in 1741, this imposing structure is the place where the Sons of Liberty first proclaimed earliest dissent against Royal oppression. Since then, it has continued to provide a forum for debate on the most consequential issues of the day.

"May Faneuil Hall ever stand as a monument to teach the world that resistance to oppression is a duty, and will under true republican institutions become a blessing."

GENERAL MARQUIS DE LAFAYETTE

Gilded Grasshopper Weathervane atop Faneuil Hall, created by America's first documented weathervane maker, Deacon Shem Drowne, and commissioned by Peter Faneuil to echo the weathervane of the London Royal Exchange, "the heart of the British Empire's financial affairs."

Statue of Samuel Adams, architect of the Boston Tea Party, founder of the Sons of Liberty, and signer of the Declaration of Independence.

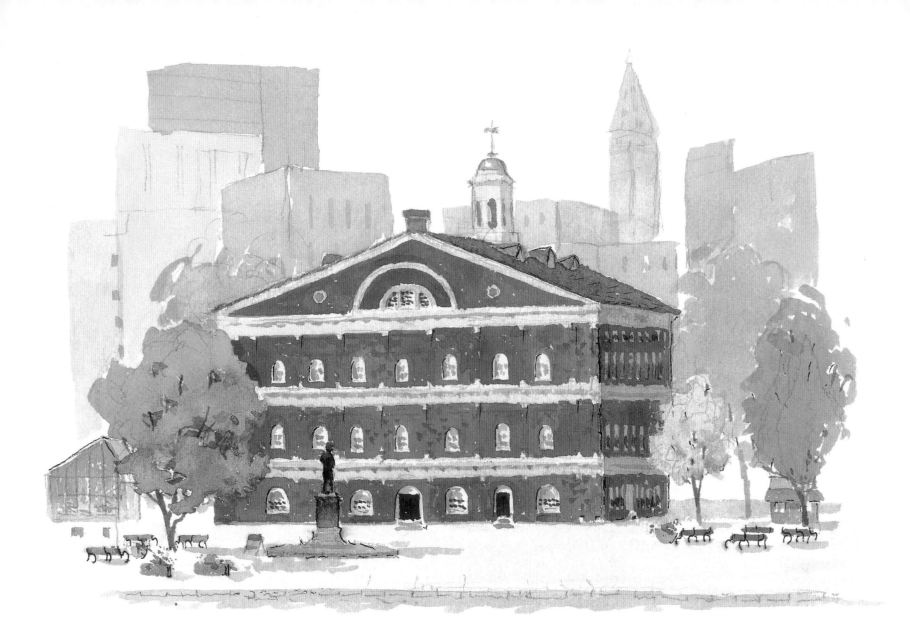

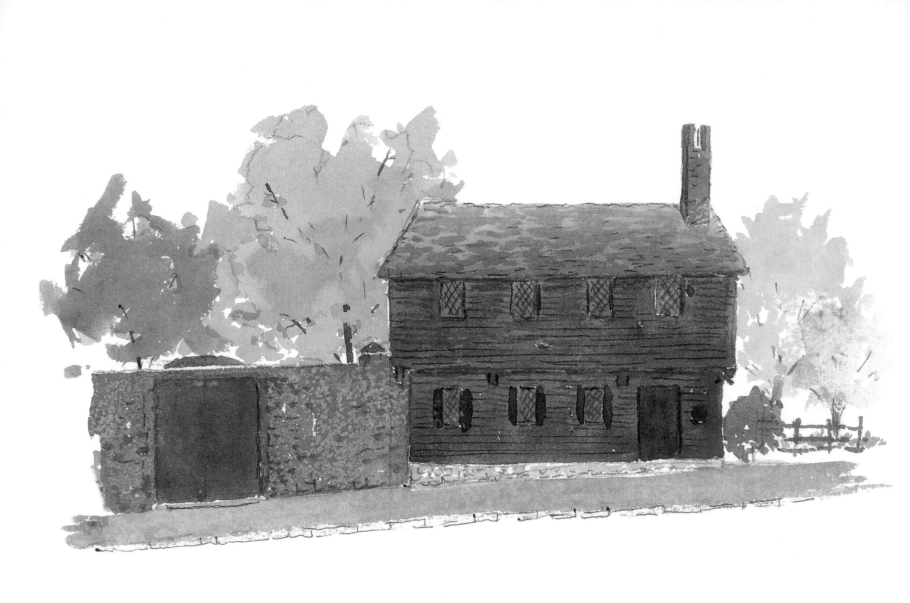

❦ Paul Revere House ❦

This modest structure is the oldest wooden building in Boston. From here, Paul Revere set out to warn Minutemen in the towns and villages near Boston that British soldiers were advancing to seize the stockpiled arms the colonists were hiding in anticipation of battle. Later, the house was a tenement for Jewish, Irish, and Italian immigrants coming to the New World. The house is now a museum.

> *"...I, Paul Revere... was sent for by Dr. Joseph Warren... to go to Lexington and inform Mr. Samuell Adams and the Honorable John Hancock, Esquire that there was a number of soldiers... marching to the bottom of the common... they were going to Lexington... or to Concord to destroy the Colony stores."*
>
> FROM PAUL REVERE'S DEPOSITION TO THE PROVINCIAL CONGRESS ABOUT THE NIGHT OF APRIL 18, 1775.

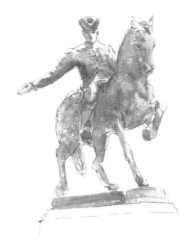

The statue at the Paul Revere Mall, in the shadow of the steeple of Old North.

The Old North Church

The very church that became a symbol of independence from the British Crown was also the place of worship for the leader of the British forces on the North American continent. General Thomas Gage was a prominent member of Old North's congregation in 1775. In April of that same year, Robert Newman, sexton of the church, crept to the steeple and sent the warning signal of two lanterns that helped to thwart British advances on towns surrounding Boston.

"he watched with eager search
The Belfry tower of the Old North Church,
As it rose above the graves on the hill,
Lonely and spectral and somber and still.
And lo! As he looks, on the belfry's height
A glimmer, and then a gleam of light!"

FROM HENRY WADSWORTH LONGFELLOW'S POEM
THE MIDNIGHT RIDE OF PAUL REVERE

*Replica of the lantern hung
in Old North Church.*

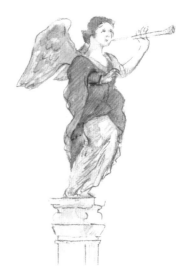

*Angel statue found in
Old North Church.*

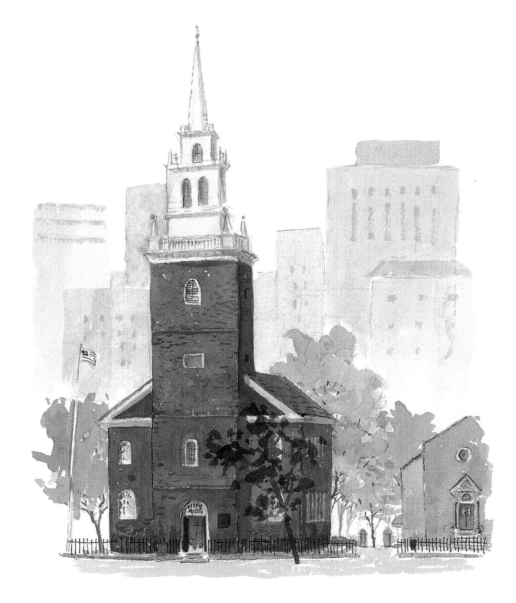

Copp's Hill Burying Ground

Copp's Hill Burying Ground is the final resting place of merchants, artisans, and craft people who lived in the North End. Located on a hill on which a windmill once stood, the land was given to the town.

The grounds are also the final resting place of thousands of free African-Americans who lived in a community on the current Charter Street side of the burying ground, called the "New Guinea Community."

Because of its height and panoramic vistas, the British used this vantage point to train their cannons on Charlestown during the Battle of Bunker Hill.

Grave marking in Copp's Hill Burying Ground.

*"Here lies buried in a
Stone Grave 10 feet deep
CAPT. DANIEL MALCOLM MERCHT.
who departed this life
October 23d
1769
Aged 44 years.
a true son of Liberty
a Friend to the Publick
an Enemy to oppression
and one of the foremost
in opposing the Revenue Acts
on America"*

The Epitaph on Capt. Malcolm's tombstone at Copp's Hill, which is riddled with the marks of vengeful British bullets

On 44 Hull Street opposite Copp's Hill Burying Ground is the narrowest house in Boston, less than ten feet wide. It is the last remnant of a series of similarly built homes from around 1800. Urban legend has it that it was built to spite a neighboring house, blocking its light and view.

USS *Constitution* – "Old Ironsides"

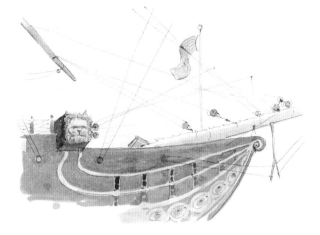

Hand-carved lion's head on the deck of the USS Constitution.

The oldest commissioned warship in the world became known as "Old Ironsides" during the War of 1812 when she fought the British Frigate H.M.S. *Guerriere*. The *Guerriere* had her masts shot off and floated dead in the water, while the cannonballs she fired at the U.S.S. *Constitution* merely "bounced off" as if she were made of iron.

In fact the *Constitution* is made of a three-layer sandwich of wood from all across America. Her "ironsides" are white oak from New Jersey, New Hampshire, and Massachusetts; her frame is the dependable live oak from Saint Simons Island off Georgia; and her masts are yellow pine from Georgia and the Carolinas.

"Huzzah! Her sides are made of iron!"

IMPRESSED SAILOR ABOARD THE *GUERRIERE*,
WHOSE EXCLAMATION GAVE *CONSTITUTION* HER NICKNAME.

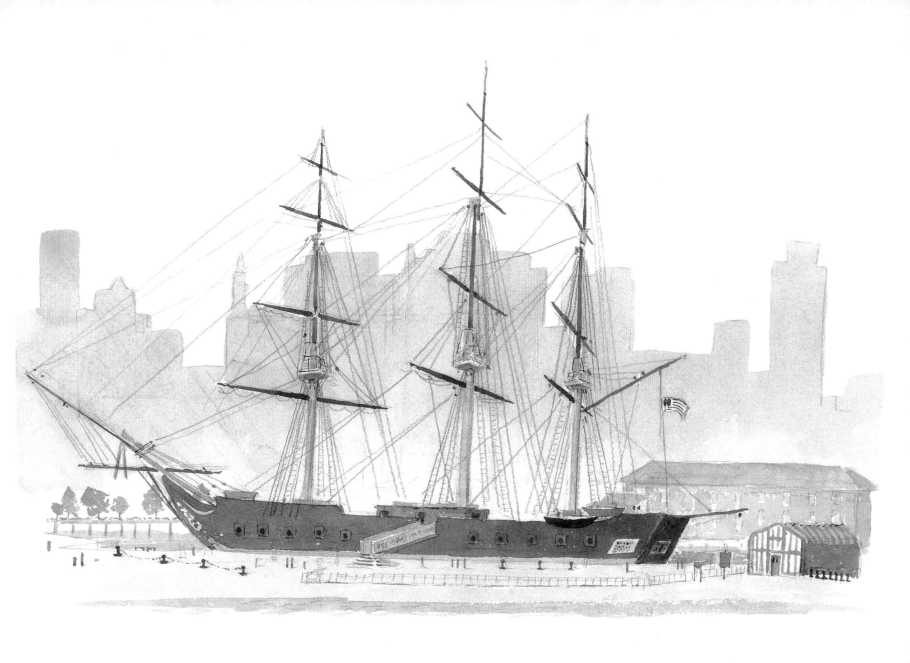

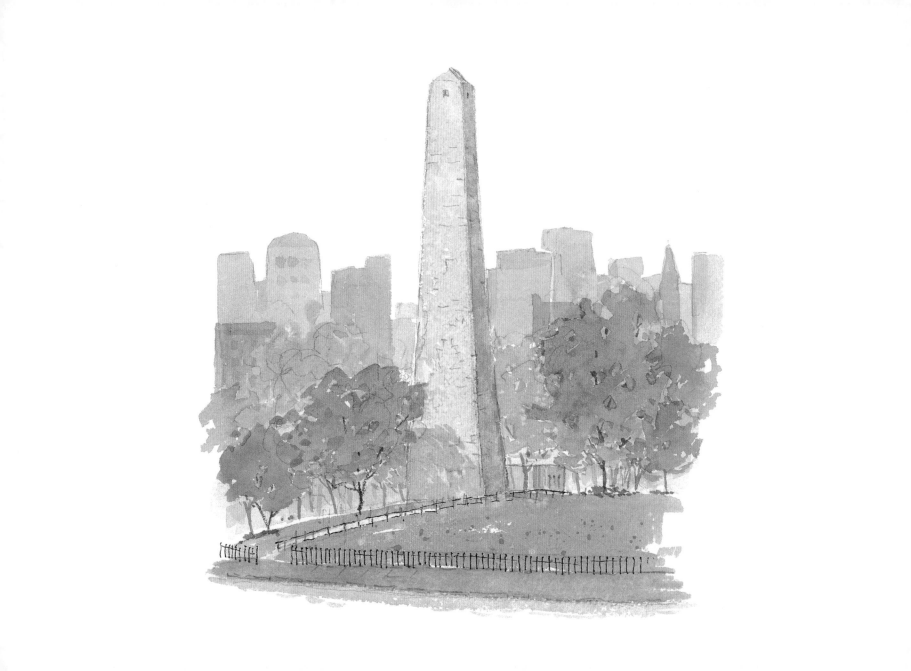

Bunker Hill Monument

"Don't fire until you see the whites of their eyes!" This famous order, which legend attributes to Colonel William Prescott, has come to immortalize the determination of the ill-equipped Colonists facing the powerful British Army during the famous battle fought on this site on June 17, 1775.

The Battle of Bunker Hill marks the first time a unified Colonial army held its own against the British army. Today a 221-foot granite obelisk denotes the site of the first major battle of the American Revolution.

Sunday June 18 1775

Dearest Friend
The Day; perhaps the decisive Day is come on which the fate of America depends. My bursting Heart must find vent at my pen. The Battle began upon our intrenchments upon Bunkers Hill, a Saturday morning about 3 o'clock & has not ceased yet & tis now 3 o'clock Sabbeth afternoon. I have just heard that our dear Friend Dr. Warren is no more but fell gloriously fighting for his Country— saying better to die honourably in the field than ignominiously hang upon the Gallows. Great is our Loss.

> *Their Honour comes a pilgrim grey*
> *To bless the turf that wraps their Clay*
> *And freedom shall a while repair*
> *To dwell a weeping Hermit there –"*

ABIGAIL ADAMS, IN A LETTER TO JOHN ADAMS
AT THE CONTINENTAL CONGRESS IN PHILADELPHIA.

Colonel William Prescott

The Freedom Trail Foundation

In 1964, the Foundation was incorporated as a non-profit organization. From 1958 to 1992 it was run, organized, and maintained entirely by volunteer support. Its early success thus was due solely to the spirit and leadership of the people of the city of Boston. The Foundation has grown considerably over the years into an organization that provides tours of the trail to 15,000 visitors a year and carries out worldwide marketing efforts to promote the trail and its sites. In 1997 Mayor Menino, the honorary chairman of the Freedom Trail Foundation, spearheaded improvements over the length of the trail amounting to more than one million dollars. This included handicap accessibility, signs, maps, information kiosks, and brass medallion markers for each site on the trail.